© 2002 Assouline Publishing for the present edition
601 West 26th Street, 18th floor
New York, NY 10001, USA
Tel.: 212 989-6810 Fax: 212 647-0005
www.assouline.com

First published by Editions Assouline, Paris, France

Translated from the French by Uniontrad

Color separation: Gravor (Switzerland)
Printed by Grafiche Milani (Italy)

ISBN: 2 84323 418 2

Ball, German poet, a thirty-year-old refugee. With his companion Emmy Hennings (she was thirty-one), and thanks to the publication of this press release, Hugo Ball was able to gather together a wide variety of artists: the poets Tristan Tzara (a nineteen-year-old Romanian) and Richard Huelsenbeck (a twenty-four-year-old German), the painters Marcel Janco (twenty-one years old) and Arthur Segal (forty-one years old), also Romanian; Hans Richter (twenty-eight years old) and Christian Schad (thirty-two-year-old), both German; the Dutchmen Otto and Adya van Rees, as well as the Alsatian Jean Arp (thirty years old) and his Swiss companion Sophie Taeuber (twenty-seven years old), also a dancer.

Three days later, the group was baptized: Dada. Hugo Ball explained the signification of this word: "Dada gets its origin from the dictionary. It's very simple. In French, it means 'hobby-horse.' In German, 'get on with it, goodbye, see you later.' In Romanian, 'yes, really, you're right, that's it, okay, really, we'll take care of it,' etc. It's an international word. Just one word."[4] Tristan Tzara added: "A word was born; we know not how DADA DADA we swore our friendship on this new transmutation, which signifies nothing, and was the greatest protest, the most intense armed affirmation for salvation liberty curse mass combat speed prayer tranquility guerilla private negation and chocolate of the desperate man."[5]

There were many who later claimed paternity, which is actually quite revealing of the Dada spirit, which systematically sought out to lead historians astray while amusing observers. Georges Hugnet told how the word was found on "February 8, 1916 using a paper knife placed randomly in a dictionary." Richard Huelsenbeck claimed responsibility for the find in the following terms: "Hugo Ball was sitting in an armchair, holding on his lap a German-French dictionary. I was standing behind him, looking at the book. Ball was pointing at the initial of each letter as he went down the

page. Suddenly, I cried 'Stop!' I was stricken by a word that I had never heard before, the word dada. 'Dada,' Ball continued to read and added: 'It's a child's word for a hobby-horse.' 'Let's take this word dada,' I said to him, 'we couldn't find anything better.' "[6] Jean Arp closed the debate with appropriate irony: "Tzara found the word Dada on February 8 at six in the evening; I was there with my twelve children when Tzara pronounced for the first time this word which generated in us such legitimate enthusiasm. It happened at the *Café de la Terrasse* in Zurich and I was holding up a brioche to my left nostril. I'm convinced that this word has no importance and that only idiots and Spanish professors could be interested in dates."

the evenings at the *Cabaret Voltaire* were veritable happenings before there were such things as happenings: some recited poems accompanied by music sometimes strange composed on drums, others created costumes and danced to devilish rhythms. Hugo Ball invented abstract, phonetic poems, like *Karawane*, which he recited on the rostrum in front of a full house, wearing a "cubist" getup: "I was wearing a costume specially designed by Janco and me. My legs were covered by a sort of column made of cardboard in brilliant blue wrapping round me up to my hips, in such a way that my lower half looked like an obelisk. On top, I was wearing an immense collaret cardboard cutout, covered in scarlet paper on the inside and gold on the outside, the whole of it held up by my neck, in such a way that I was free to let it fly like wings by raising and lowering my elbows. To this was added a cylindrical Shaman headdress, very high, with blue and white stripes (...) I started off very solemnly:

t he Mona Lisa wearing a mustache entitled *L.H.O.O.Q.*[1], that's Dada. A pretty mirror in a golden frame, entitled *Portrait of an Imbecile*, that's Dada. A poem consisting solely of consonants, that's Dada. "Advice on personal hygiene: put the marrow of the sword in the hair of the lady", that's Dada. A "painting" made of trash, a urinal exhibited in a museum, all that's Dada. "Dada stirs it all up. Dada knows all. Dada spits it all out." But who is Dada?

"Dada is a virgin microbe / Dada is against life so dear / Dada / Corporation exploiting ideas / Dada has 391 different attitudes and colors, depending on the President's sex / It transforms itself— asserts—says exactly the opposite at the same time—no importance—cries—goes fishing / Dada is the chameleon of rapid, self-interested change / Dada is against the future, Dada is dead, Dada is dumb / Long live Dada, Dada is not a literary school, screams Tristan Tzara."[2] So then, what is Dada?

Let's just say that "If you have serious ideas on life, you make artistic discoveries, and all of a sudden your head starts to break up in laughter, if you find that all your ideas are useless and ridiculous, know that DADA HAS BEGUN TO SPEAK TO YOU."[3]

Thus spoke the Dadaists, no matter what the nationality, united by the desire to clear the table, so to speak, of that which structured modern society: its social organization, its values—religion, culture, art—its habits and customs. They were painters, poets, sculptors, typographers, photographers. They formed their own government, published their own reviews, exhibited for and against everything, and, above all, they caused scandals. Who were they? How and when did they meet each another? What combats did they fight? What did they create? How did they mark their era and their century?

the war. But in Zurich, in a neutral country in the heart of a Europe tearing itself apart, a small group of young artists rose up against the general massacre by founding a sort of literary and artistic café: the *Cabaret Voltaire*. "Under this name," ran a press release dated February 2, 1916, "a young gathering of artists and writers has established itself with the goal of creating a center for artistic leisure. The cabaret principle shall provide for daily meetings with programs including music and poetry performed by artists present in the audience. All the young artists from Zurich, from all backgrounds, are hereby invited to provide their aid and their suggestions." As early as February 5th, three knocks were knocked at the backroom of a tavern. The cabaret review mixed all the arts (painting, music, dance, singing, poetry) within a local theater, according to the wishes of its pioneer, Hugo

THE DADA SPIRIT

EMMANUELLE DE L'ÉCOTAIS

ASSOULINE

For Laurent,

gadji beri bimba
glandridi lauli lonni cadori
gadjama bim beri glassala
glandridi glassala tuffm I zimbrabim
blassa galassasa tuffm I zimbrabim...

That was too much. After an initial consternation before these never-heard-before sounds, the audience ended up exploding."[7]
actually, these phonetic poems expressed a desire to "get down to the most profound alchemy of the word, and even go beyond it to preserve the most sacred domain of poetry." (Hugo Ball) The same goes for plastic arts and music: the dada evenings at the *Cabaret Voltaire* showed the desire to get back to the basics of humanity, whose primitivism seemed like the pure element *par excellence*, a kind of remedy against the ravages of modernity: war. So, many Zurich evenings were marked by the so-called primitive arts, with reading and interpretation of verses, negro dances and music.

All the Dada artists were in fact fundamentally hostile to the war. Together, they attempted to escape from the atmosphere of sordid violence. Jean Arp explained: "In Zurich, disinterested by the slaughterhouses of the world war, we devoted ourselves to the fine arts. While off in the distance could be heard the thunder of the drums, we hung, we recited, we versified, we sung with all our hearts. We were looking for an elementary art which we thought could save man from the furious folly of our time. We hoped for a new order to reestablish balance between the sky and hell. This art very quickly became a subject of general blame. It's not surprising that the "bandits" were unable to understand. Their childish obsession with authoritarianism attempts to make art make man stupid." (*Dadaland*)

The goal of the first Dada publication (the *Cabaret Voltaire*, May 15, 1916) was to "present the public with the activities and interests of

the *Cabaret Voltaire*, whose only goal, beyond war and homelands, is to make sure the few independent spirits who live for other ideals are remembered."

If the tone of this first publication shows at the movement's start Hugo Ball's fairly calm state of mind as the pioneer of these soirées, he was quickly supplanted by the vivacious and enthusiastic personality of the young poet Tristan Tzara, discovered right from the first issue of the review *Dada*, in June 1917. Tzara's virulence led Dada toward a radical attitude: "There is great destructive, negative work to be done," he maintained, "if one day we hope to rebuild."

t he artists then adopted a common means to act: much room was given to irony, casualness, chance and provocation in their art. Traditions, "systems" and art, this expression which is superior to man, were ridiculed. Tzara explained in his first Dada Manifesto in 1918: "I am against systems; the most acceptable system is the one that has no principles." [8] Just as he proclaimed, "Dada means nothing," plastic creation should represent nothing: "We need strong, straight, precise works, never misunderstood. Logic means complication. Logic is always false. [...] Married to logic, art was living in incest, engulfing, eating up its own tail, its own body, fornicating with itself... the temperament becomes a tarred nightmare of Protestantism, a monument, a pile of grayish, heavy intestines."

So Dada designates an insolent, ironic, combative spirit, essentially anti-artistic. And, in opposition to traditional art, chance was erected as a principle of creation: Jean Arp, in his work *Rectangles arranged according to the laws of chance* (1916) each piece of

paper was chosen at random and placed randomly on the medium. The glued paper as the cubists had already experimented had already destroyed the technique; Arp achieved the crisis point of this procedure by eliminating the last traditional "artistic" notion that still subsisted in pictorial images, i.e. the "composition" of the work, the arrangement of forms one according to another.

I t was this anti-artistic attitude that could be found most often in the different members of the Dada movement. This spirit, however, already could be found before the birth of the movement in the person of Marcel Duchamp.

While Duchamp was considered as a painter influenced by cubism and futurism in 1912 (especially with his famous *Nude Descending a Staircase*), his work in the following year showed a profound desire to eliminate the hand of the artist from pictorial creation: that's the case for *Chocolate Grinder*, the quasi-industrial tone of which tends to give the impression that it is not a painting. In 1913, he went even further: he actually placed an upside-down bicycle wheel on a stool (*Bicycle Wheel*). But there was still an element of "composition" present. By 1914, Marcel Duchamp was able to eliminate this last artistic reference: he purchased at the *Bazar de l'Hôtel de Ville* a bottle holder that he signed, dated and presented as a work of art, thereby inventing the "ready-made." The industrial object was transformed into a work of art by the simple choice of the artist. Aesthetics were abolished, along with all the traditional notions of art, like composition, the stroke, the technique, and all the logic and comprehension of the work that Tristan Tzara would speak about a few years later. Dada was born.

Another characteristic of Dada, the establishment of chance as a principle of creation, was also a part of Marcel Duchamp's work in the years 1913-1914. His best example is *Three Standard Stoppages*: this new unit of length invented by Duchamp was obtained by letting three, one-meter, horizontal strings fall from one meter high. The strings lose their linear shape "to their liking" and this deformation is conserved in a box. A new law was being implemented, the law of chance against an established system; the standard meter, parodied.

discharged, Marcel Duchamp went into exile in New York in 1915, where he found other artists sharing the same interests as him, such as the Frenchmen Francis Picabia, Albert Gleizes and Jean Crotti, or the Americans Man Ray, Joseph Stella and Morton Schamberg. Together they formed a New York branch to the Dada movement. Marcel Duchamp was no doubt the strongest personality of the group, but he and Man Ray got along very well. The work the latter had done before meeting Duchamp—and especially the publication of the review *The Ridgefield Gazook* in March 1915—showed the same provocative spirit. Duchamp, in New York for the first time, had however already gained a reputation as a "hero" thanks to his success with *Nude Descending a Staircase at the Armory Show* in 1913.

Duchamp continued in New York with the path he'd set out for himself. In 1917, he sent to the *Salon des Indépendants* an upside-down porcelain urinal signed "R. Mutt" (the name of the manufacturer), dated 1917 and titled *Fountain*. Of course the work was refused. And of course it bore witness to the same anti-artistic and

provocative spirit already shown by the Dadaists in Zurich.

Probably influenced by Duchamp's mechanical drawing *Chocolate Grinder*, as early as 1916 Picabia created works inspired by it, such as *Universal Prostitution*. Man Ray was also attempting to abandon classical pictorial techniques, first with the collage (*Revolving Doors*, 1916), then with the aerograph (*Admiration of the Orchestrelle for the Cinematograph*, 1919), and finally, through photography. He created some of the most significant Dada works with this medium. For example, *Man* (1918), the photograph of an egg beater hanging on a wall. Beyond the theme itself of imagery, such as *Chocolate Grinder* by Duchamp, or his ready-mades, it is important to highlight the ironic and provocative nature of that which is induced by the title *Man*, changed two years later into *The Woman*. This "sex-change" could be attached to another, much more popular one, by Duchamp in 1920: inventing for himself a new identity, the artist put on make up and dressed in women's clothes for Man Ray's camera, calling himself Rrose Sélavy (i.e. phonetically "Eros, c'est la vie"—*Eros means life*).

In April 1921, Duchamp and Man Ray published the sole issue of the review *New York Dada*. Its cover is made up of a background of endless upside down printed words: *"New York Dada April 1921"*. In the center stands a work by Duchamp: an ordinary perfume bottle whose sticker has been redone, with a medallion containing the portrait of Rrose Sélavy by Man Ray, and below the inscription of the play on words: *Belle Haleine, Eau de Voillette* (1921). But, as Man Ray wrote to Tristan Tzara a little while later, "Dada can't live in New York." Marcel Duchamp, then Man Ray, left for Paris the following summer.

Dada was also a very politically engaged movement, especially in Germany. In 1918, Berlin was nothing more than an open wound where unemployment and famine proliferated. At every street corner,

cripples and invalids bore witness to the terrors of the trenches. *Le Marchand des allumettes* [The Matchstick Salesman] by Otto Dix (1920) depicted the bitter reality: a blind, legless cripple with one arm tries to sell matchsticks to uninterested passers-by when a dog urinates on him.

I n this way, the artists rose up against authority and rebelled against the establishment of the Weimar Republic. Dada in Berlin was profoundly antibourgeois, anti-liberal and their many events showed strong political affiliations, in particular favor of the Spartakist revolution. The major protagonists of the "Dada-Berlin Government" were Richard Huelsenbeck—who left Zurich in 1917—the "Welt-Dada" (World Dada), Raoul Hausmann the "Dadasoph", John Heartfield the "paste-up editor Dada", George Grosz the "Marschall Dada" or "Propagandada", and Johannes Baader the "Ober Dada" (Supreme Dada). They founded a Dada Club and published a manifesto in 1918. Their review (Der Dada, begun in 1919), directed by Raoul Hausmann, invented a new type of letterpress printing. In 1920, they carried out their first Great International Dada Fair. Their slogans were disconcerting because of the diverse staging of artworks, signs chanting such provocative sayings as "Down with art! Down with bourgeois spirituality." Posters and photographs were pinned to the wall and mannequins were tied to the ceiling. One effigy was dressed like a German soldier with a pig's head that wore a sign: "Hanged by the revolution."

Through these examples, one better understands the interest Dada had for photography and its evident realism. With the invention of

the photomontage, including famous examples such as *Tatlin at Home* and *ABCD* by Raoul Hausmann (1920 and 1923), or *Ten Years Later*: *Fathers and Sons* by John Heartfield (1924), Dada expressed its "aversion to playing at being artists". Dada claimed to "construct, assemble" its works[9] in such a way that the artists considered themselves "as engineers". This outlook partially explains the distinctive characteristic of the Dada movement in Berlin, which placed more emphasis on machines than movements elsewhere. As a result, the major protagonists associated themselves with the Russian constructivists a few years later. Exemplary works like *The Spirit of our Time* (Raoul Hausmann, 1919) or the panel announcing that "Art is Dead—Long live the new art of the machine—by Tatlin" were also exhibited during the first Great International Dada Fair.

Geographically isolated from the group, in Hanover, Dadaist Kurt Schwitters created in 1919 an original art he called *Merz*. Like Dada, this word "means nothing" and was taken "totally at random" from the word "*Kommerzbank*." Kurt Schwitters was a painter, sculptor, editor and typographer. He also created environmental (the *Merzbau*, started in 1920), happenings before they were popular, and wrote poems and stage plays. While his works "represent nothing," in the fashion of Jean Arp, they did retain a sense of composition and aesthetics related notably to cubism. His most important works are, no doubt, the collages and the assemblies. The artist's raw materials were "anti-artistic," because they consisted of scraps and trash, and the execution of his works, always fairly quick, worked to take away the sacred aura of the artistic act; heir organization was not left up to chance, however, and more often than not, letters and words were used to add a poetic meaning to the works. In fact, Kurt Schwitters was different from the Dadaists in that he had a very high opinion of art and its

role in the construction of a new world. In practice, his attitude was very provocative and therefore Dada, when he declared: "Everything an artist spits out is art" (in *Kunst ISM*, 1925). In search of total art, Schwitters was able to believe that he, as an artist, was art himself.

I n Cologne, three artists brought life to Dada starting in 1919: Max Ernst, who had just been demobilized, and Johannes Theodor Baargeld—painter, poet and founder of a Rhine constituent of the communist party—joined with Jean Arp (who was newly returned from Zurich) a few months later. In the meantime, Max Ernst and Baargeld published a communist newspaper, *Der Ventilator*, which had a circulation of up to 20,000 copies. Therefore they had a political interest similar to the Dadaists of Berlin. From an artistic standpoint, these Cologne artists devoted most of their energy to collages. Max Ernst invented his own method, which consisted in cutting out things he found in technical reviews—usually natural sciences—which he then glued together and embellished with watercolors and drawings. These paintings were composed of elements taken out of context and juxtaposed in such a way that they gave rise to strange images, even if they were almost always figurative. The title, often written on the work itself, contributed to the work's mystery and poetry.

The most significant element of the Dada movement in Cologne was the creation of a collage production company by the three artists: the Zentrale W/3 (W for West, 3 for Jean Arp, J.T. Baargeld and Max Ernst.) They gave rise to a series of "anonymous" works: including the *Fatagaga*, abbreviation for "fabrica-

tion de tableaux garantis gazométriques" [manufacture of guaranteed gazometric paintings], among various other photomontages and collective collages.

Like other Dada events in the world, the Cologne branch had its scandalous event: "Early Spring Dada" in April 1920. The works of Baargeld and Ernst stirred the animosity of the public, bringing about the intervention of the police and the closing of the exhibit. This was especially the case with *La Parole or la Femme Oiseau* [The Word or the Bird Woman], a collage which reexamines Albrecht Dürer's Eve (1504). It was considered obscene because the freedom of its interpretation. Finally, Baargeld and Ernst published the review *Die Schammade*, which helped them establish contact with the Parisian group, the members of which subsequently invited Max Ernst to join them.

In Paris, the rise of Dada owed at least some thanks to the meeting between two people: Francis Picabia and Tristan Tzara. They had corresponded with each other since 1918 and had met in early 1919, after the publication of the *Dada Manifesto* by Tzara in 1918.

t zara's manifesto coerced a few young Parisian poets, including André Breton, who wrote to the young Rumanian: "I really liked your manifesto; I didn't know I would be able to find someone with the courage you show. I now turn all my attention to you. (You don't really know who I am. I am twenty-two, I believe in the genius of Rimbaud, of Lautréamont, of Jarry; I absolutely loved Guillaume Apollinaire, I have a profound tenderness for Reverdy. My favorite painters are Ingres and Derain; I appreciate the art of Chirico.) I am not so naïve as I seem."[10]

The meeting with Tzara came quickly, and had such importance that Breton, Soupault and Aragon participated in issues 4 and 5 of the *Dada* review.

In 1918, André Breton, Louis Aragon and Philippe Soupault published their works in Pierre Reverdy's review *Nord-Sud*. But the sudden death in November 1918 of Guillaume Apollinaire, whose participation had been essential, brought the publication to an end. This void was quickly filled by the creation of *Littérature*, a review founded by those who were now called the "three musketeers" (Breton, Aragon and Soupault).

Picabia, Ribemont-Dessaignes, Tzara, Breton, Aragon and Eluard in Paris, the first protagonists of the Dada movement, were much more focused on literature than anywhere else. During the only Literature Friday, held on January 18th, 1920, Tristan Tzara's first public appearance was easily as enjoyable as the evenings spent at the *Cabaret Voltaire*.

The events continued, culminating in the Dada Festival, salle Gaveau, on May 26. On the program, an "unbelievable event, all the Dadaists will shave their heads in public. There will be other attractions: a painless fist fight, presentation of a Dada illusionist, a veritable flashy foreigner, a vast opera, sodomite music, a twenty-voice symphony, an immobile dance, two plays, manifestos, poems. Finally, we shall know Dada's sex."[11]

The Dadaists then created their own publishing house called Au Sans Pareil; the offices also were used for exhibits. Max Ernst's exhibit in May 1921 attracted all of Paris and became the model for Parisian Dada events: "The Dadaists, not wearing ties, sporting

white gloves, came and came again. André Breton chewed on matchsticks, Georges Ribbemont-Dessaignes cried out at every moment 'It's raining on a head.' Aragon meowed, Philippe Soupault played hide-and-go-seek with Tristan Tzara, and Benjamin Péret held hands with Chachourne all the while. On the threshold (where a mannequin stood smiling enigmatically), Jacques Rigaut counted aloud the automobiles and pearls of the female visitors."[12]

In the month of June of that same year, the International Dada Salon was an outright success. Similar to the Berlin fair, although less abundant, there was an accumulation of a diverse mix of objects and works from Germany (Max Ernst), Italy, America (Joseph Stella and Man Ray) and Switzerland (Jean Arp). A catalogue made by Tzara went along with the event, as well as the performance of a play, *Le Cœur à gaz* [The Gas Heart], also by Tzara.

t he movement's "headquarters" were located in a café, the *Certà*. The artists met there and "received" visitors and new arrivals, like Man Ray. Having arrived in Paris during the summer of 1921, he discovered a painting in Francis Picabia's studio that he was invited to sign: *L'Œil cacodylate*. This work, long exhibited at the *Bœuf sur le toit*, shows, underneath a painted eye, the signatures and plays on words of all the artists, musicians and writers who came through Picabia's studio.

Man Ray, whose talent as a photographer was quickly recognized by the Dadaists, became their regular portraitist. His personal creations and especially his discovery of the photogram, which he rebaptized "rayography," were enthusiastically received. This photographic technique involves the placing of objects directly on

light-sensitive paper and then exposing them. It resulted in unique photographs, without negatives, which were nothing other than the direct imprint of the objects that had been transcribed in contrary values. In 1922, Man Ray published an album of these compositions, *Delicious Fields*, with an introduction by Tristan Tzara who considered this to be "the purest form of Dada."

Marcel Duchamp participated in the Parisian movement with a few "assisted" ready-made works, like the portrait of the Mona Lisa wearing a mustache that was insolently called *L.H.O.O.Q.* After completing his major work in 1923, *The Bride Stripped Bare By Her Bachelors*, Even (or *The Large Glass*, a work that he had started nearly ten years earlier), he announced his decision to quit painting and devote all his time to his true passion: chess. His participations at Dada events by that time were, in any case, nothing more than sporadically accounted for in the group's reviews. We can cite, for instance, this play on words signed by Rrose Sélavy: *"Il faut dire: la crasse du tympan, et non le sacre du printemps."*[13] [Literally: You must say: the grime on the eardrum, and not the rite of spring.]

dada was international. It appeared in Italy, Czechoslovakia, what was then the USSR, Hungary, Belgium and the Netherlands. But while its existence was rather brief (Dada officially died in 1924 with the birth of surrealism), its posterity loomed large. Its "style" did not give way to a school, because there was no "Dada style", rather its spirit of irony, doubt, provocation, anarchy, revolt and negation en masse of all values of modern society inspired others. One does not say

Dadaism, but Dada. After 1945, and into the present day, the Dada spirit can be found in many artistic movements like pop art, Fluxus, new realism, etc.: Andy Warhol's Campbell's soup cans and bottles of Coca-Cola are more contemporary examples of Dada. Arman's accumulations and Cesar's compressions are Dada. Ben, when he paints "this is not art," is Dada. Today, Dada corresponds to what we call "counter culture:" rap is Dada, tags are Dada. In sum: Dada is dead, long live Dada!

1. If you read the letters aloud in French, the following phrase is formed: elle a chaud au cul…
2. In *Dadaphone*, n° 7, March 1920.
3. Manifesto *Dada Stirs it All Up*, (Paris, 1921).
4. Manifesto of Hugo Ball read aloud at the first Dada evening, on July 14, 1916, published for the first time in French in *Dada Zurich Paris, 1916-1922* (Paris, Jean-Michel Place, 1981).
5. *Chronique zurichoise* by Tristan Tzara, published in 1920 in the *Almanach dada* (directed by Richard Huelsenbeck, Berlin, 1920).
6. R. Huelsenbeck, "Dada Lives", in *Transition*, n° 25, 1936.
7. Hugo Ball, *Die Flucht aus der Zeit* [Escape outside of Time] (Munich-Leipzig, Dunker & Humblot, 1927), translation quoted by Marc Dachy in *Journal du mouvement dada* (Genève, Skira, 1989).
8. In *Dada*, n°3, December 1918.
9. Raoul Hausmann, 1958, quoted by Marc Dachy, *op. cit.*
10. Quoted by Marc Dachy, *op. cit.*
11. Press release quoted by Michel Sanouillet in *Dada à Paris* (new, enlarged edition, Paris, Flammarion, 1993).
12. Quoted by Michel Sanouillet, *op. cit.*
13. In *Le Cœur à barbe*, [the Bearded Heart] April 1922.

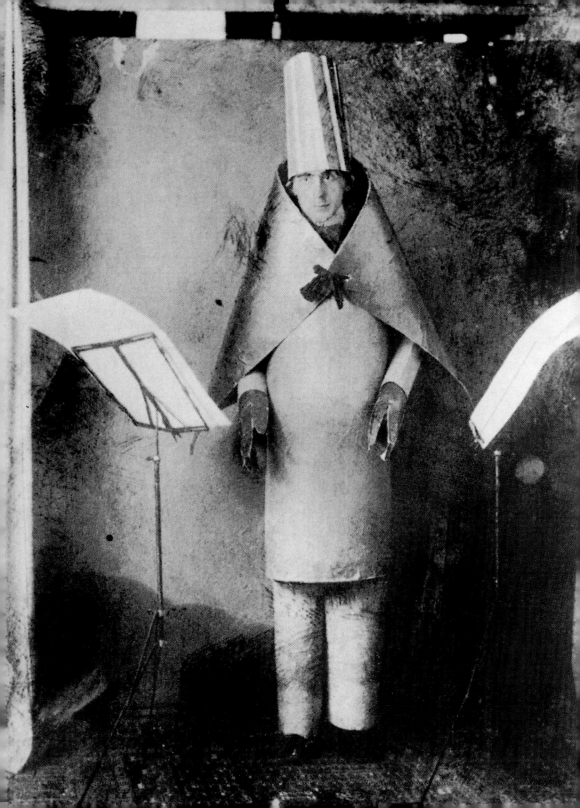

CABARET VOLTAIRE

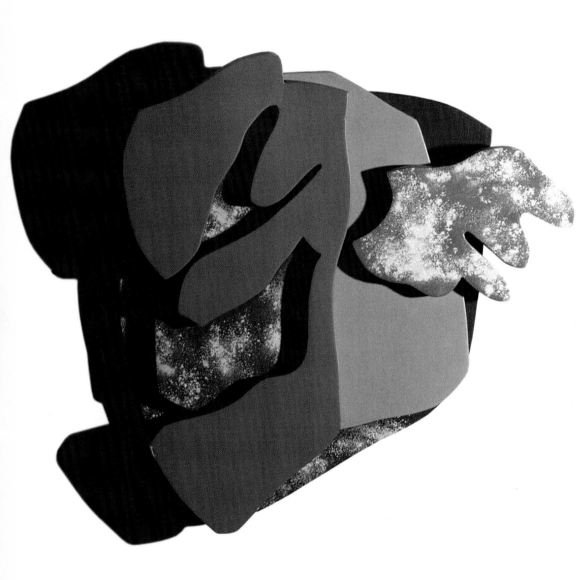

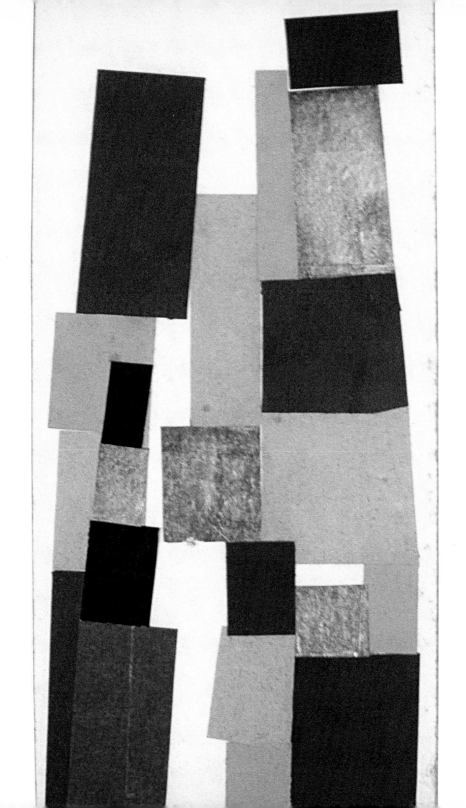

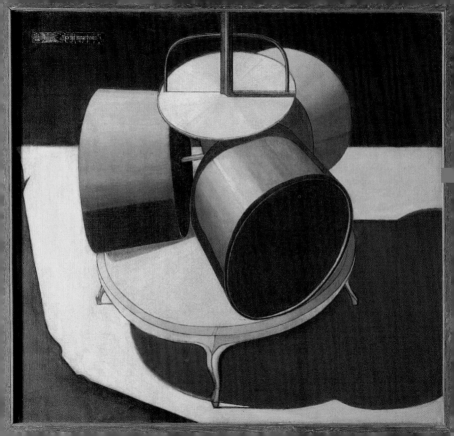

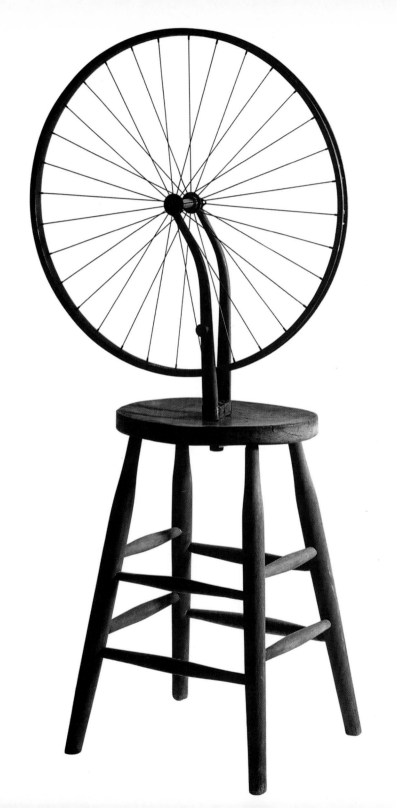

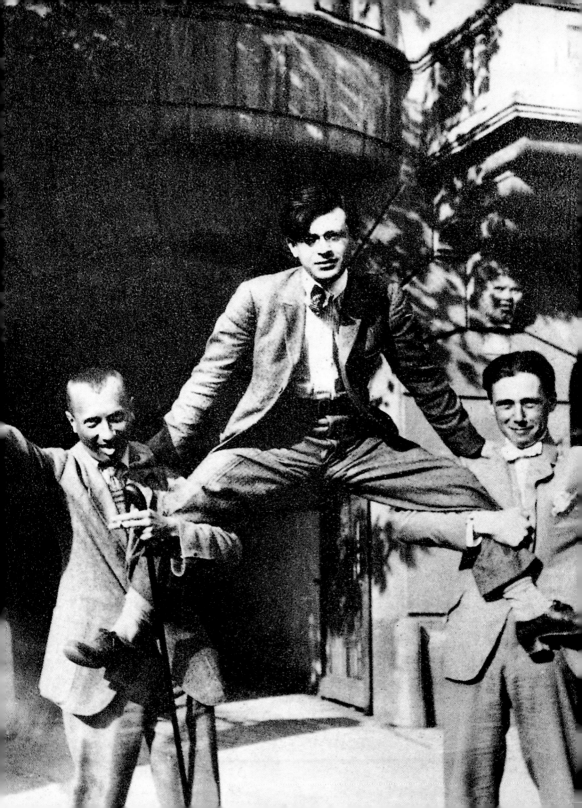

da
da dada
dadadadadada

dada da da

dada dada dada

dada dada

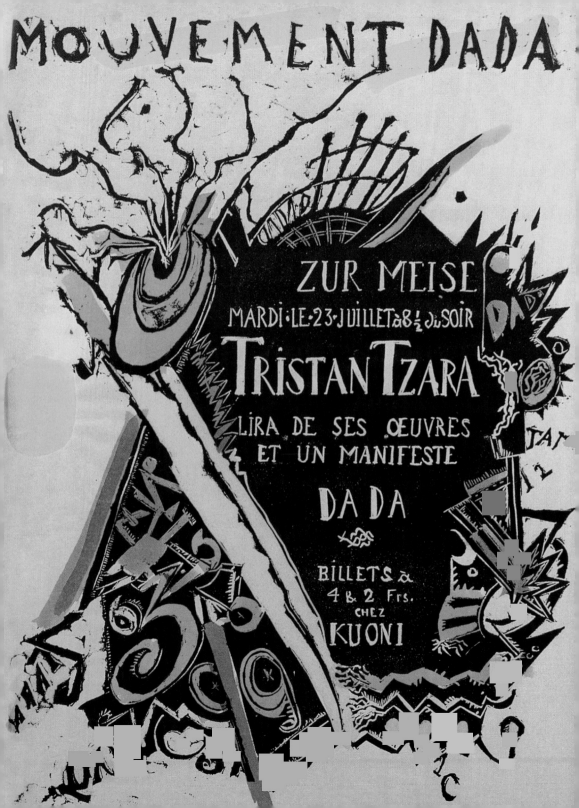

MOUVEMENT DADA

ZUR MEISE
MARDI·LE·23·JUILLET à 8½ du SOIR
TRISTAN TZARA
LIRA DE SES ŒUVRES
ET UN MANIFESTE
DADA

BILLETS à
4 & 2 Frs.
CHEZ
KUONI

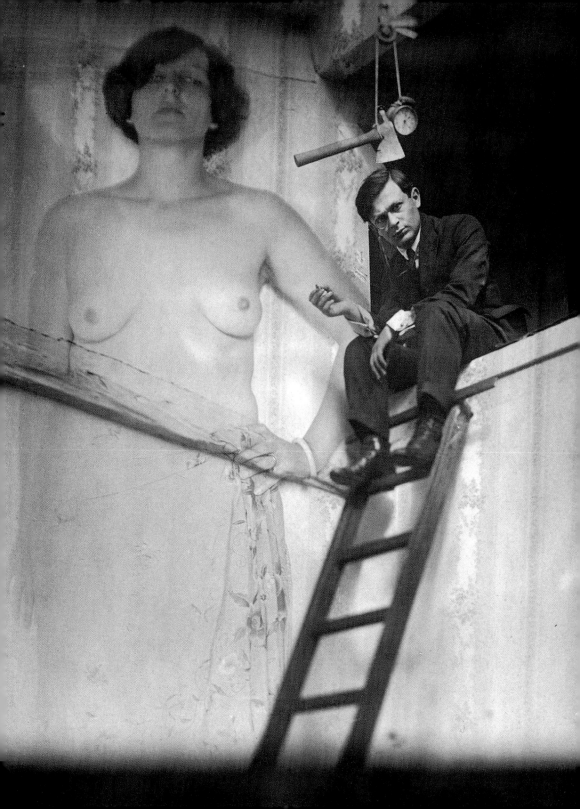

(Les Signataires de ce manifeste habitent la France, l'Amérique, l'Espagne, l'Allemagne, l'Italie, la Suisse, la Belgique, etc., mais n'ont aucune nationalité).

DADA SOULÈVE TOUT

DADA connaît tout. DADA crache tout.

MAIS.......

DADA VOUS A-T-IL JAMAIS PARLÉ :

OUI = NON

OUI = NON

OUI = NON

de l'Italie
des accordéons
des pantalons de femmes
de la patrie
des sardines
de Fiume
de l'Art (vous exagérez cher ami)
de la douceur
de d'Annunzio
quelle horreur
de l'héroïsme
des moustaches
de la luxure
de coucher avec Verlaine
de l'idéal (il est gentil)
du Massachussetts
du passé
des odeurs
des salades
du génie . du génie . du génie
de la journée de 8 heures
et des violettes de Parme

JAMAIS JAMAIS JAMAIS

DADA ne parle pas. DADA n'a pas d'idée fixe. DADA n'attrape pas les mouches

LE MINISTÈRE EST RENVERSÉ. PAR QUI ? PAR DADA

Le futuriste est mort. De quoi ? De DADA

Une jeune fille se suicide. A cause de quoi ? De DADA

On téléphone aux esprits. Qui est-ce l'inventeur ? DADA

On vous marche sur les pieds. C'est DADA

Si vous avez des idées sérieuses sur la vie,

Si vous faites des découvertes artistiques

et si tout d'un coup votre tête se met à crépiter de rire,

si vous trouvez toutes vos idées inutiles et ridicules, sachez que

OUI = NON

C'EST DADA QUI COMMENCE A VOUS PARLER

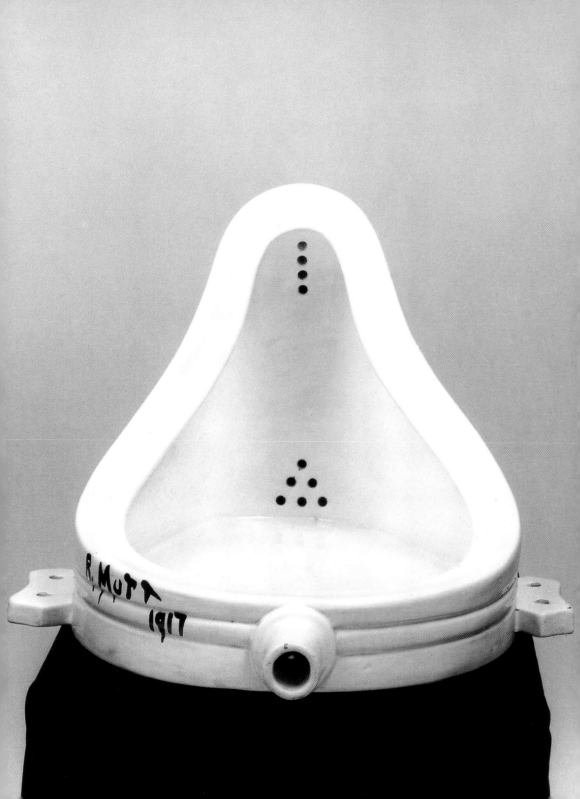

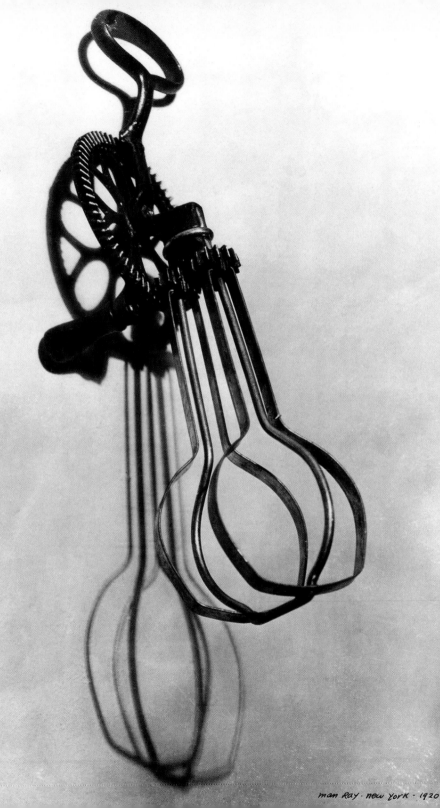

LA FEMME

man Ray · New York · 1920

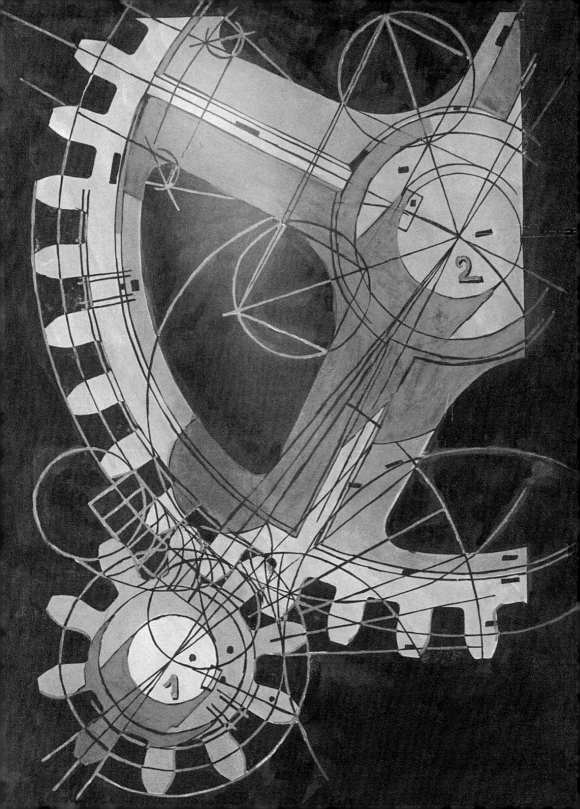

BELLE HALEINE
Eau de Voilette
RS

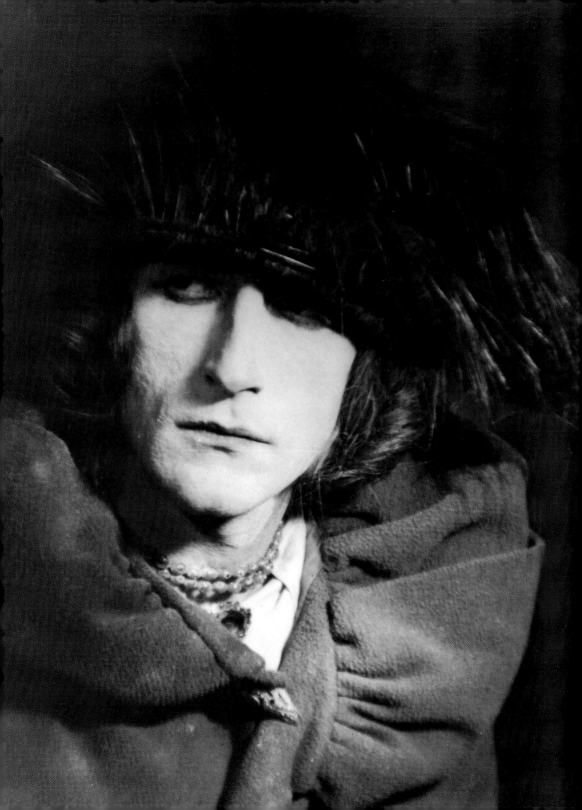

Nehmen Sie
DADA ernst,
es lohnt sich!

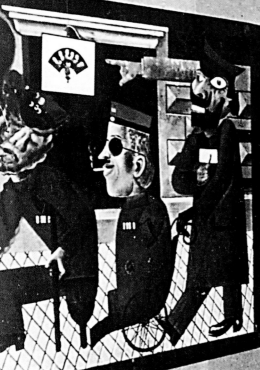

N.V.E
27 22

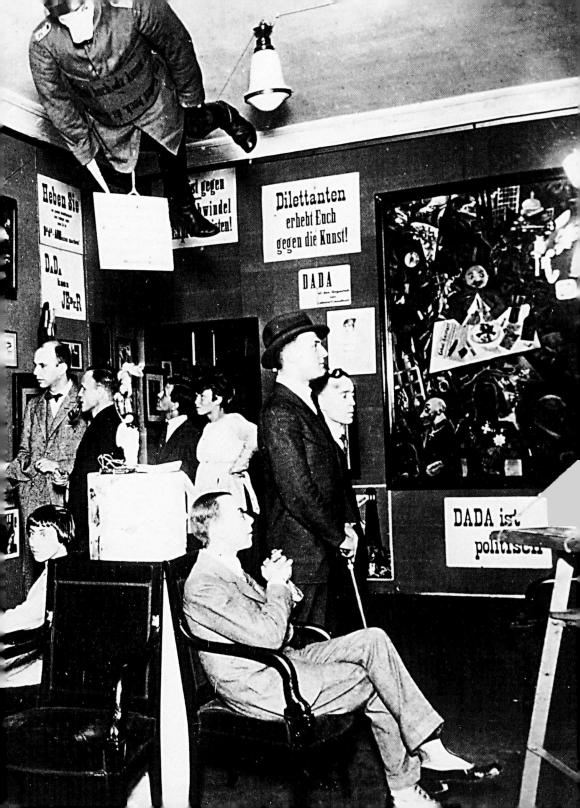

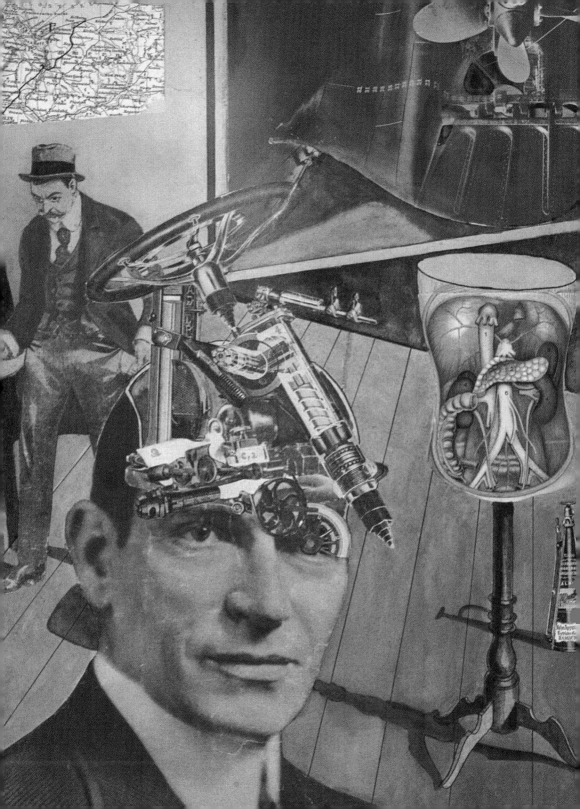

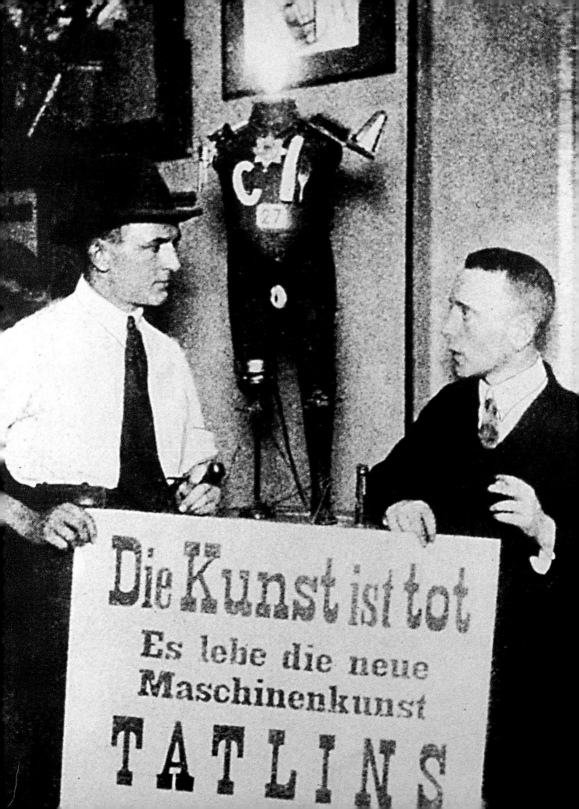

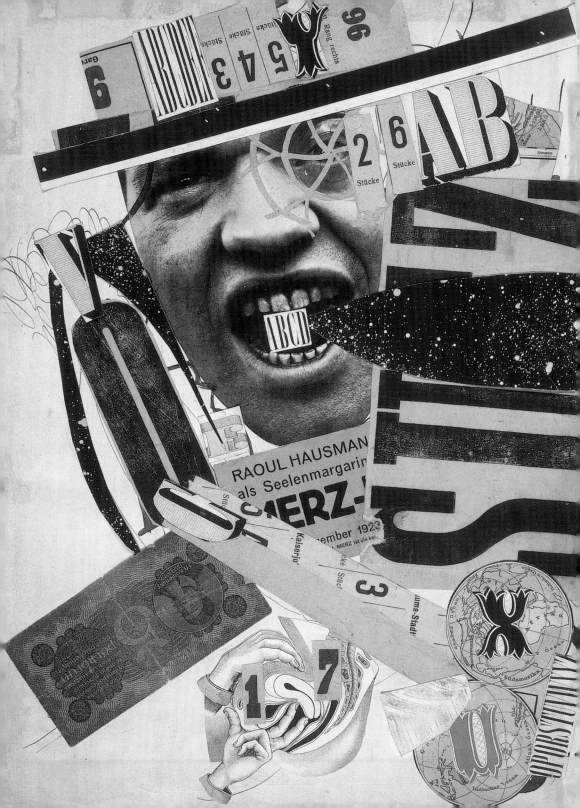

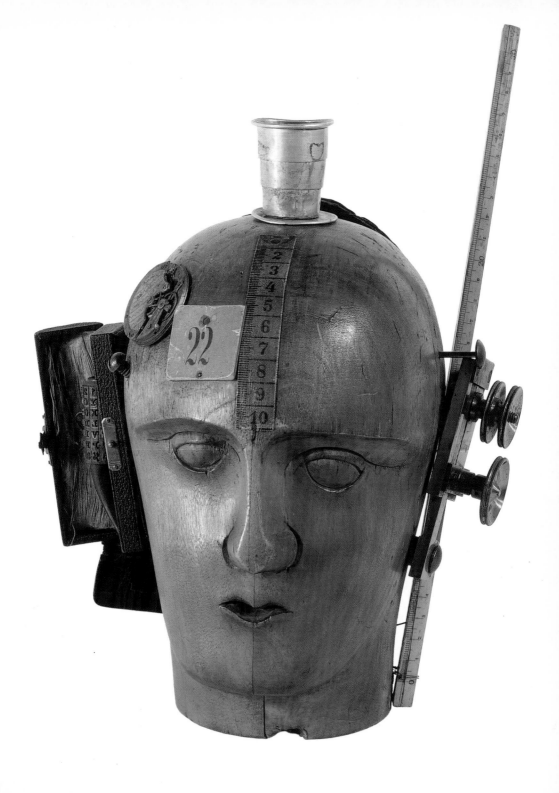

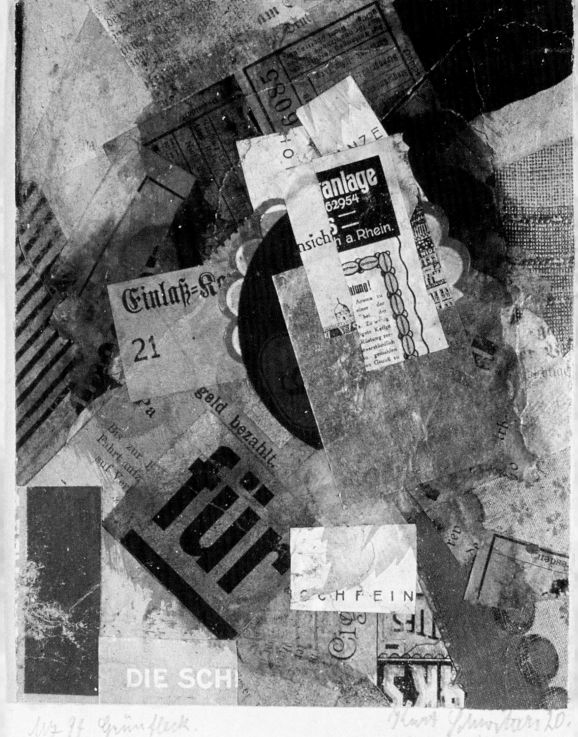

Mz 97 Grünfleck. Kurt Schwitters 20.

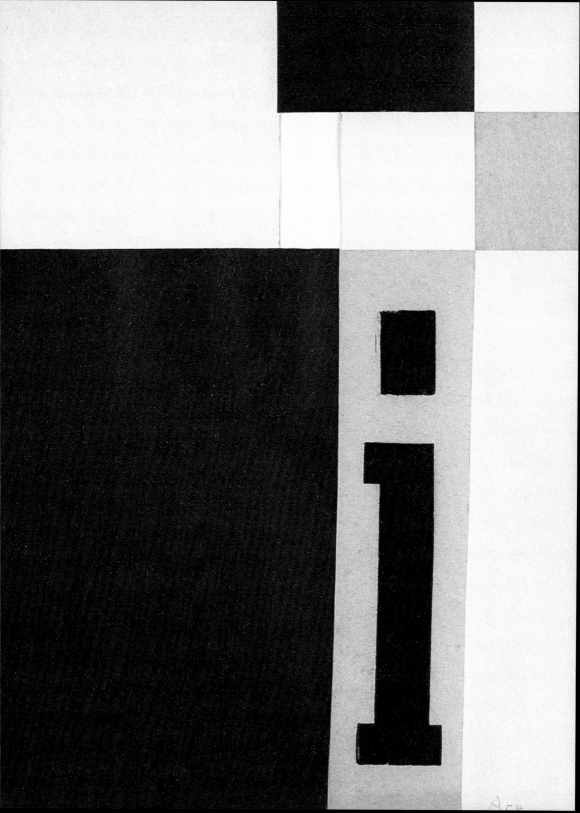

EXCURSIONS & VISITES DADA

DADA UN CULTE NOUVEAU :

LEÇONS DE COUPE

DADA

1ÈRE VISITE :
Église
Saint Julien le Pauvre

PROCHAINES VISITES :
Musée du Louvre
Buttes-Chaumont
Gare Saint-Lazare
Mont du Petit Cadenas
Canal de l'Ourcq
etc.

JEUDI 14 AVRIL A 3 h.
RENDEZ-VOUS DANS LE JARDIN DE L'ÉGLISE
Rue Saint Julien le Pauvre — (Métro Saint-Michel et Cité)

COURSES PÉDESTRES DANS LE JARDIN

Les dadaïstes de passage à Paris voulant remédier à l'incompétence de guides et de cicerones suspects, ont décidé d'entreprendre une série de visites à des endroits choisis, en particulier à ceux qui n'ont vraiment pas de raison d'exister. — C'est à tort qu'on insiste sur le pittoresque (Lycée Janson de Sailly), l'intérêt historique (Mont Blanc) et la valeur sentimentale (la Morgue). — La partie n'est pas perdue mais il faut agir vite. — Prendre part à cette première visite c'est se rendre compte du progrès humain, des destructions possibles et de la nécessité de poursuivre notre action que vous tiendrez à encourager par tous les moyens.

* EN BAS LE BAS — EN HAUT LE HAUT

Sous la conduite de : Gabrielle BUFFET, Louis ARAGON, ARP, André BRETON, Paul ELUARD, Th. FRAENKEL, J. HUSSAR, Benjamin PÉRET, Francis PICABIA, Georges RIBEMONT-DESSAIGNES, Jacques RIGAUT, Philippe SOUPAULT, Tristan TZARA.

(Le piano a été mis très gentiment à notre disposition par la maison Gavault.)

MERCI POUR LE FUSIL

et encore
une fois
BONJOUR

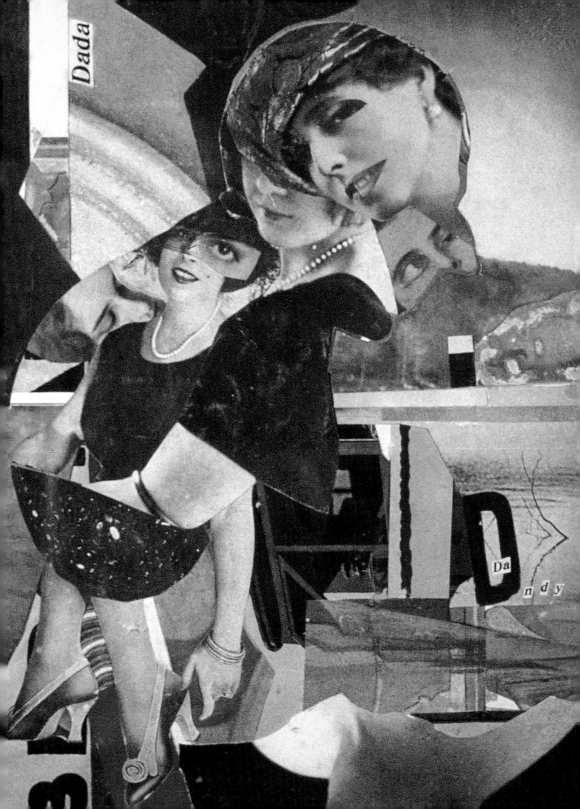

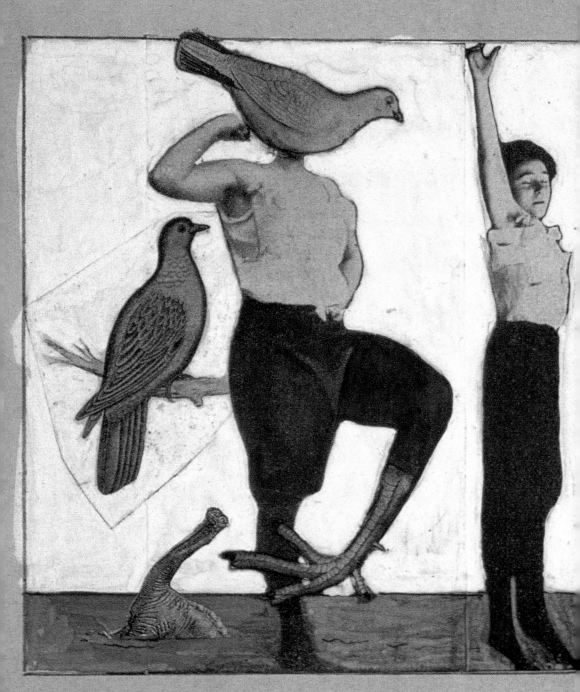

max ernst / arp.

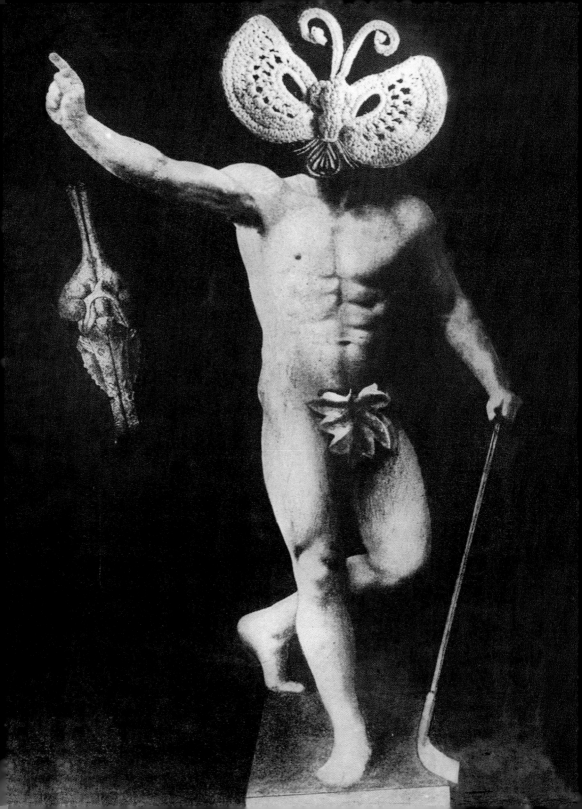

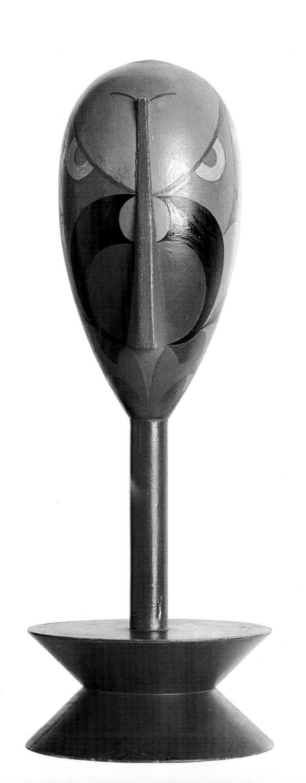

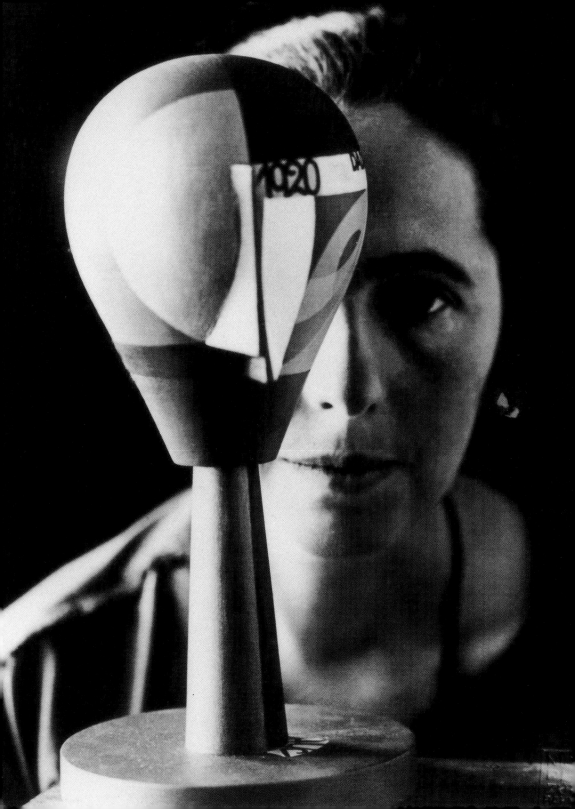

DADA 3

Directeur :

TRISTAN TZARA

Bois de M. Janco.

Je ne veux même pas savoir s'il y a eu des hommes avant moi. (Descartes)

Administration

Mouvement DADA

Zurich

Zeltweg 83

POUR QUE VOUS AIMIEZ
QUELQUE CHOSE IL FAUT
QUE VOUS L'AYEZ VU et ENTENDU

DEPUIS LONGTEMPS tas D'IDIOTS

FRANCIS PICABIA

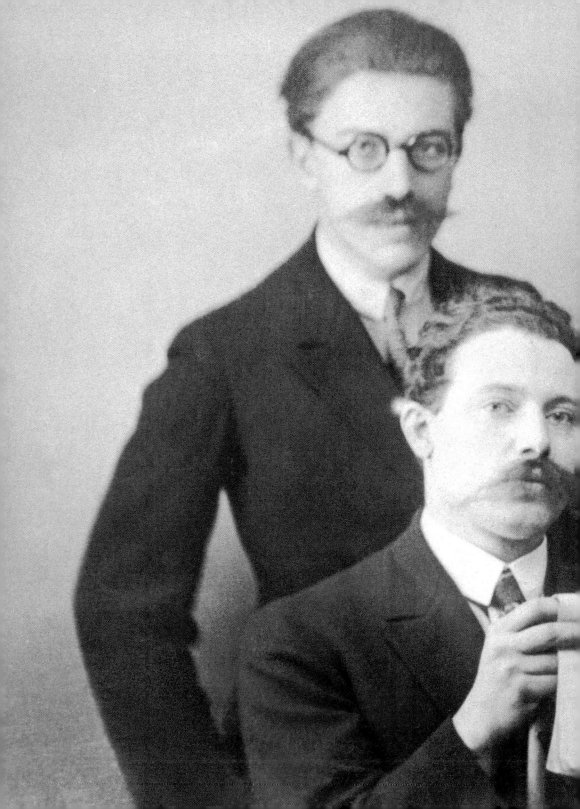

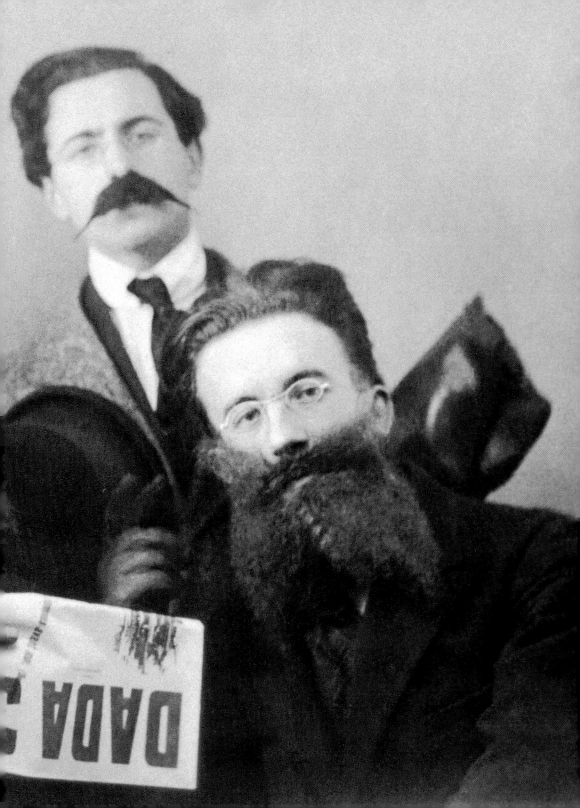

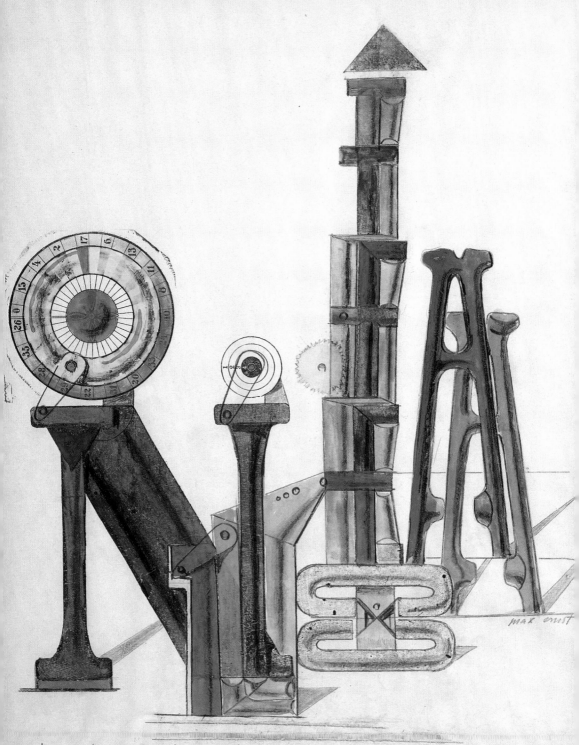

la grande roue orthochromatique qui fait l'amour sur mesure

caesar buonarroti

5000

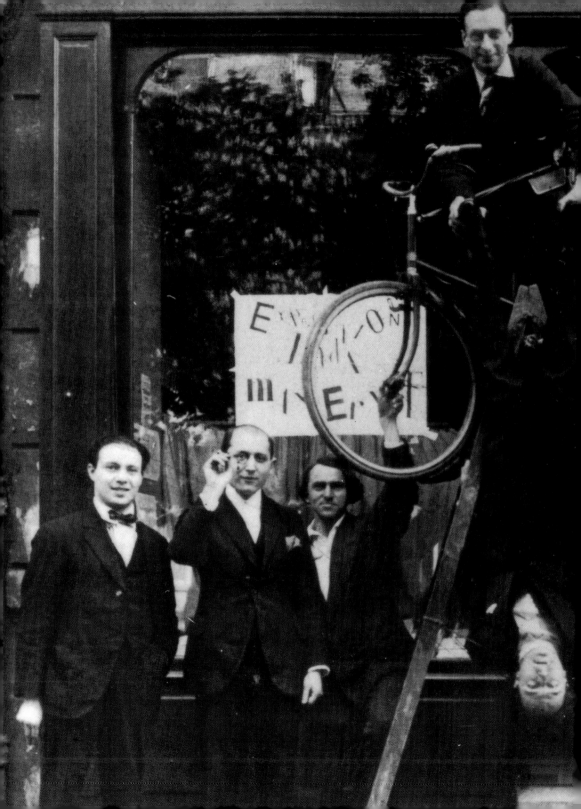

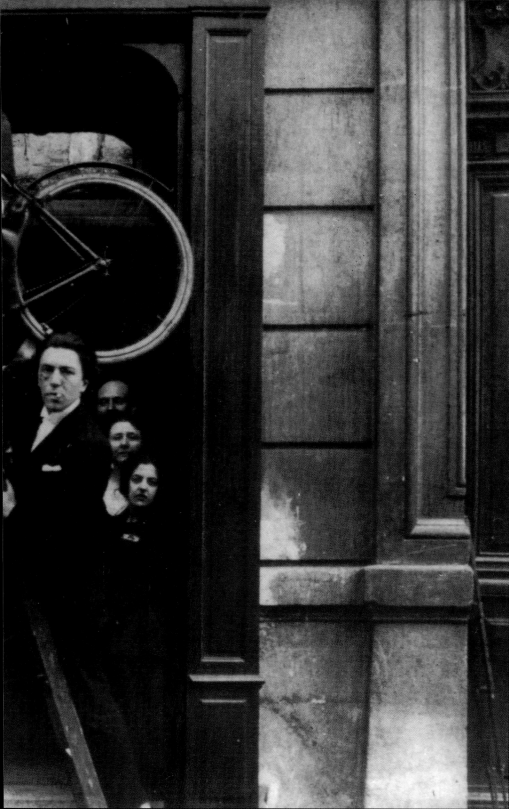

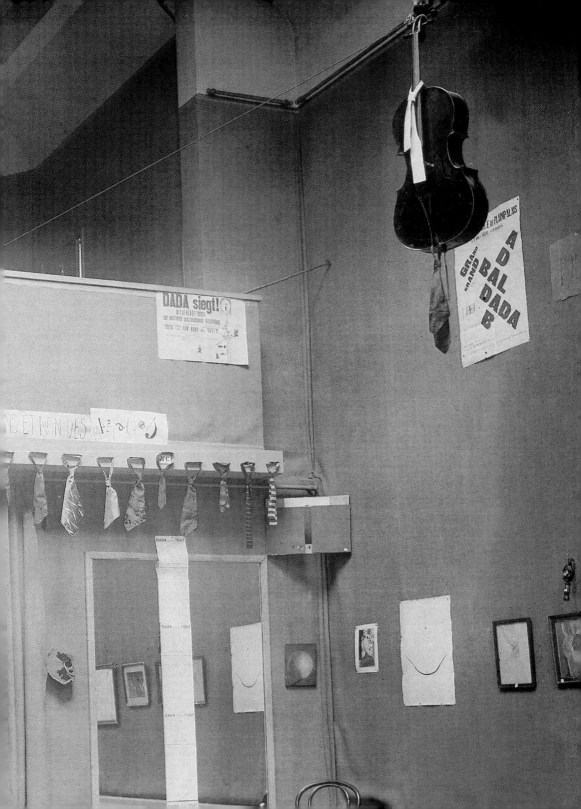

L'ŒIL CACODYLATE

Paul "Z" final Dermée

Tout le monde ont signé je signe y. Moreau

Je m'appel DADA depuis 189. Mill

car ce que le ou hose que c'est bien! Se taire: il est mieux

Je m'arrive de la campagne Metzinger céline

MON

À chacun sa bucque au tien MARGUERITE BUFFET.

en DEUIL de verre

Couronne de mélancolie

VOUS REGARDE FATTY J. Co

GOOD LUCK

Ricciotto Canudo Je prête sur moi-même G. Ribemont Dessaignes

Comprendre? S. Antoine Sali no

VOILÀ RougesLabla JEA

Moi, j'aime FRANCIS et germaine

Marcelle Errard

Parlez pour moi. J. Rigaut.

Se on

à Francis Picab

IL FAUT MAIS JE NE PEUX PAS

MOI Je suis Tête Suzanne Duchamp

Je n'ai rien à vous dire Georges Auric

qui raconte du his toir

Gabriele Buffet de néga

C'est difficile

H. Jousdan-Morhange Non je ne signerai pas.

Dunoyer Sergent

VIVE AGAGA PANSAERS PICABIA Te SOUVIENS T

ON CŒUR BAT VALENTINE J. HUGO

René Bleyé

PHARAMOU

e petit de Massot

SOURIT u GRAND PICABIA !

SOLEIL RUSSE

Je bénédicte J. Pevolo

J'aime la

S. CHARCHOUNE

CHÈRE ME TOUJOURS RÉVEILLER! GERMAINE EVERLING

J'aime Léo Claretz

RENATA BORGATTI LES CROISSANTS SONT BONS

"Francis Picabia" par Maria de LA HIRE

JE ME TROUVE TRÈS

ISADORA AIME PICABIA DE TOUT SON

RIEN FAIT ET JE SIGNE J'aime aussi FRANÇOIS HUGO J'aime

TRISTAN TZARA

FRANCIS PICABIA

Hania

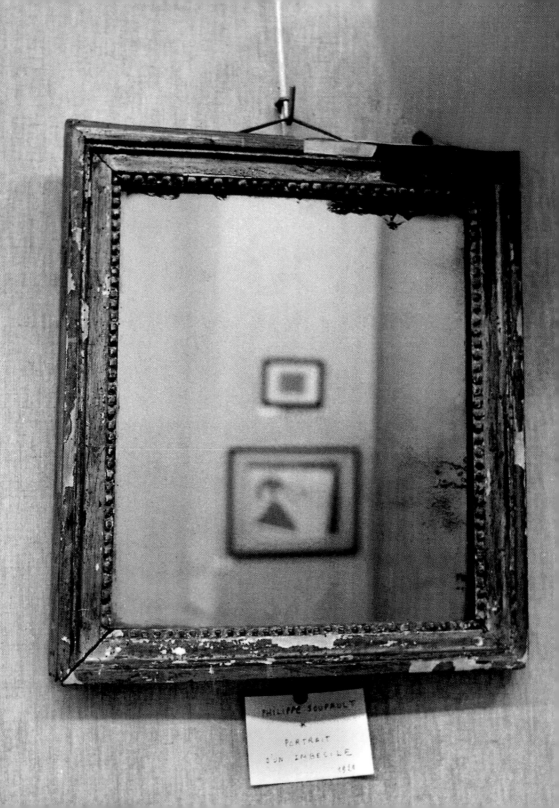

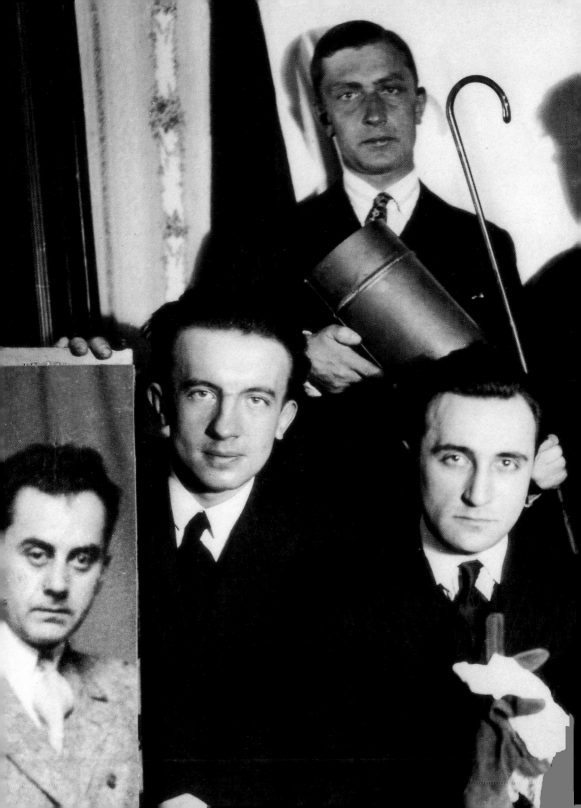

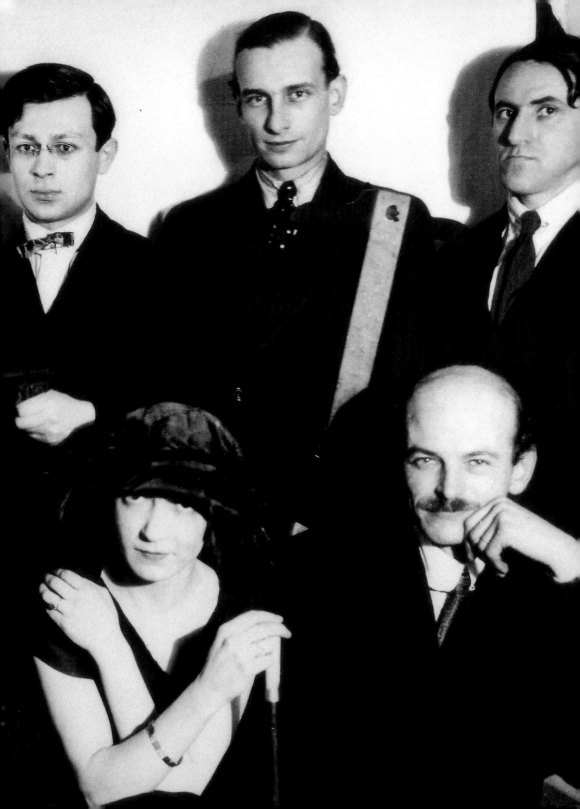

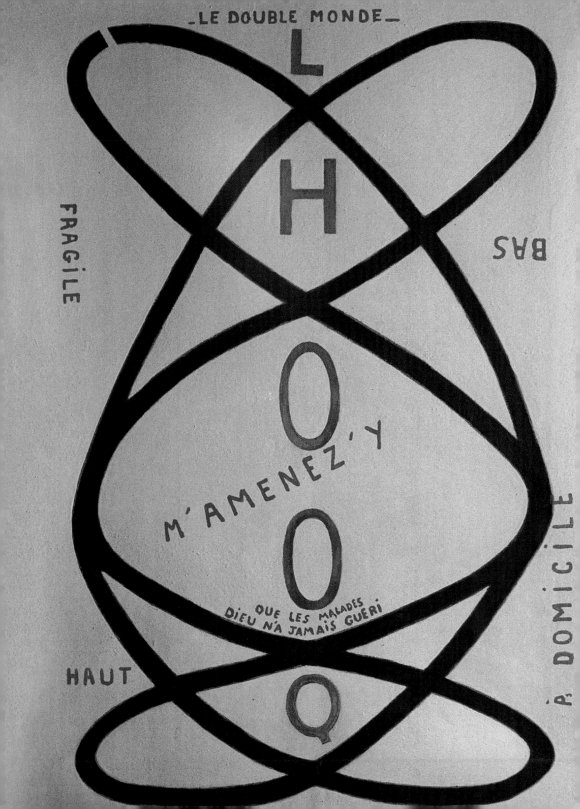

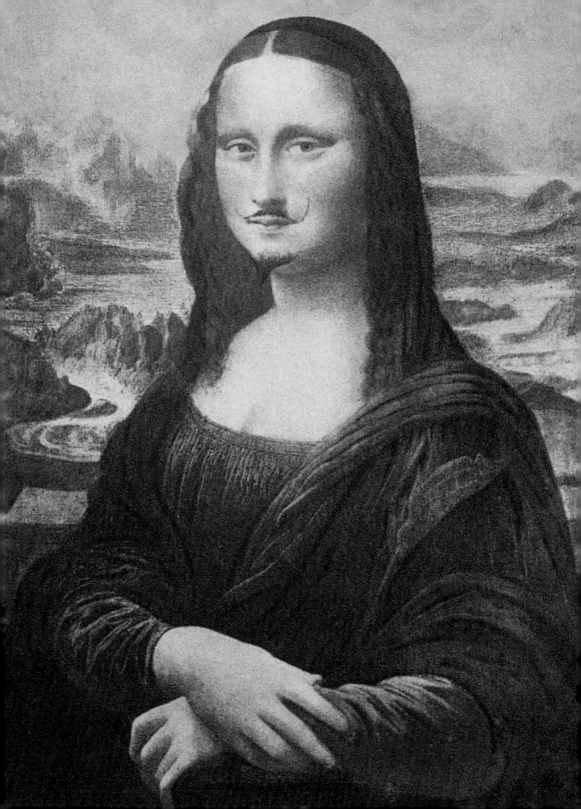

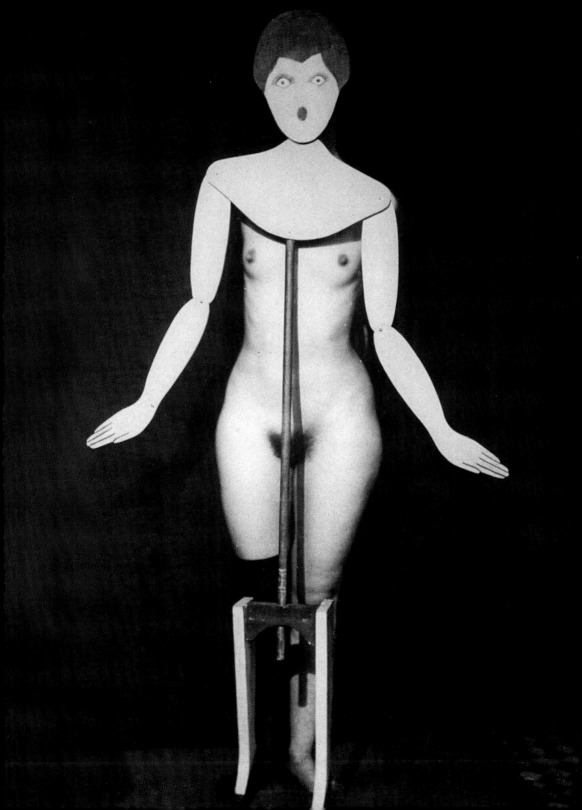

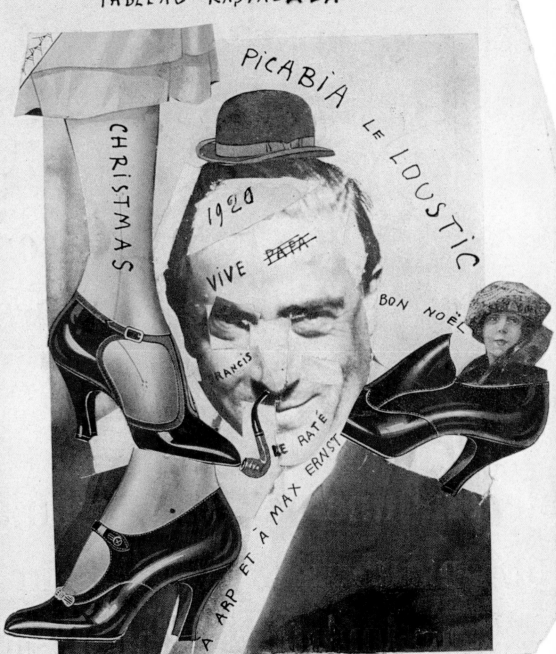

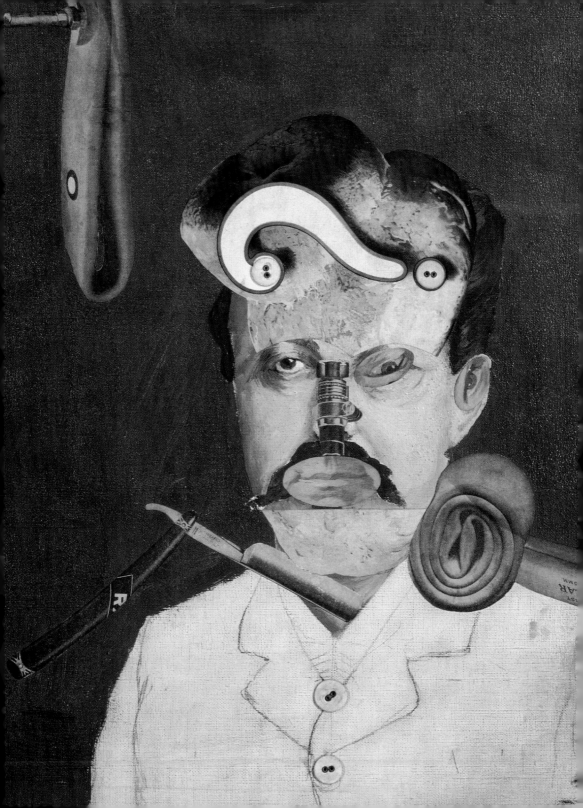

Chronology

1916
Zurich February 5th: Hugo Ball founds the *Cabaret Voltaire* with Emmy Hennings, Jean Arp, Sophie Taeuber, Marcel Janco, Tristan Tzara and Richard Huelsenbeck. A few days later, they baptize their movement "Dada."
June: publication of the only issue of the review *Cabaret Voltaire*. Hugo Ball reads his phonetic poem *Karawane* at the *Cabaret Voltaire*.
July: Tristan Tzara publishes *The First Heavenly Adventure of Mr. Antipyrine* with Marcel Janco's colored wood.
August: arrival of Hans Richter.
October: Huelsenbeck leaves for Germany.
Autumn: Tzara sends copies of *The First Heavenly Adventure of Mr. Antipyrine* to Marius de Zayas, Duchamp and Picabia in New York, creating the first connections between Zurich and New York.

1917
Zurich January 27: opening of the first Dada exhibit at the Corray Gallery, accompanied by three conferences given by Tzara.
July: first issue of the review *Dada*.
Barcelona January: first issue of *391*, published by Picabia.
New York April: return of Picabia. Publication of *The Blind Man* by Marcel Duchamp. Duchamp sends his urinal, entitled *Fountain*, to the Salon des Indépendants. It is refused.
August: publication of the only issue of *Rong Wrong* by Duchamp.
October: Picabia leaves for Switzerland.

1918
Berlin January: foundation of the Dada Club by Huelsenbeck. The following are members: Johannes Baader, George Grosz, Raoul Hausmann, Hanna Höch, John Heartfield, Wieland Hertzfelde and Franz Jung.
April: Huelsenbeck writes his *Dadaist Manifesto*.
Lausanne February: Picabia meets Tzara and Arp.
Hanover June: Kurt Schwitters' first exhibit.
Zurich July: public reading of *Dada Manifesto 1918* by Tzara, later published in the third issue of the review *Dada*, published in collaboration with Picabia.

1919
Berlin February: publication of the manifesto *Dadaisten gegen Weimar* [The Dadaists against Weimar].
May: first Dada exhibit.
June: publication of the first issue of *Der Dada*, directed by Raoul Hausmann.
Paris March: publication of the first issue of *Littérature*, directed by Breton, Aragon and Soupault.
New York March: Man Ray publishes the review *TNT*.
July: Duchamp leaves for Paris. He would return to New York the following December.
Hanover June-September: exhibit of the first *Merz* by Schwitters.

George Grosz, Remember Uncle August, *1919, Oil, pencil, paper and five buttons glued to the canvas.*
49 x 39.5 cm. Musée national d'Art moderne, Paris. © Mnam, Centre Georges-Pompidou, Paris.

1920

Paris January: arrival of Tzara. On January 23, first Friday Literature is held at the Palais des Fêtes. .
April 25: Picabia and Tzara publish the first issue of *Cannibale*.
May: special issue of *Littérature* with twenty-three Dada manifestos.
May 26: Dada Festival, salle Gaveau, in Paris.
July: publication of *Jésus-Christ Rastaquouère* [Jesus Christ, Flashy Foreigner] by Picabia.

Cologne April: Dada exhibit closed down by the police

New York April 29: foundation of the corporation by Katherine Dreier, Man Ray and Marcel Duchamp: the very first American museum dedicated to modern art.

Berlin April 29: foundation of the corporation by Katherine Dreier, Man Ray and Marcel Duchamp: the very first American museum dedicated to modern art..

1921

Paris January: *Dada soulève tout* [Dada stirs it all up] pamphlet.
April 14: pamphlet announcing the opening of the "great Dada season" in Paris.
May: arrival of Marcel Duchamp. Picabia published in *Comoedia* the article "Picabia se sépare des Dadas" [Picabia leaves the Dadas].
May 3: Dada exhibit of Max Ernst at the *Au Sans Pareil* Gallery.
June 6: Dada Salon, International Exhibit, Montaigne Gallery.
July 22: arrival of Man Ray.
December: Man Ray exhibit at the Six bookstore.

New York 22 January: Duchamp asks "permission" from Tzara to publish a Dada review.
April: publication of the *New York Dada* by Man Ray and MarcelDuchamp.

1922

Holland February: Theo van Doesburg publishes the dada review *Mecano* under the pseudonym I.K. Bonset.

Paris Breakup of Dada, argument between Breton and Tzara; Picabia attacked in *La pomme de pin*. Second series of *Littérature* under André Breton's direction.
April: Tzara published *Le Cœur à barbe*, transparent newspaper on colored paper.

Weimar September: Constructivism-Dada congress.
Hanover: Dada soirée organized by Schwitters with Arp, Hausmann, Tzara and van Doesburg.

1923

Netherlands January: publication of the first issue of the review *Merz* by Schwitters.

Paris July: final Dada events. Performance of *Cœur à gaz* by Tzara at the Michel theater. Violent conflicts with the future surrealists.

1924

Paris July: publication of the *Sept manifestes dada* [Seven Dada manifestos], *Lampisteries* by Tzara.
October: last issue of the Picabia's review 391.
December: publication of the *Manifeste du surréalisme* [Surrealism Manifesto] by André Breton. First issue of the review *La Révolution surréaliste* [The Surrealist Revolution] directed by Pierre Navile and Benjamin Péret.

Man Ray, Rayography, excerpt from the album Champs délicieux, 1922. 22.2 x 17.5 cm.
Cnac Georges-Pompidou, Paris. © Centre Georges-Pompidou, Paris.

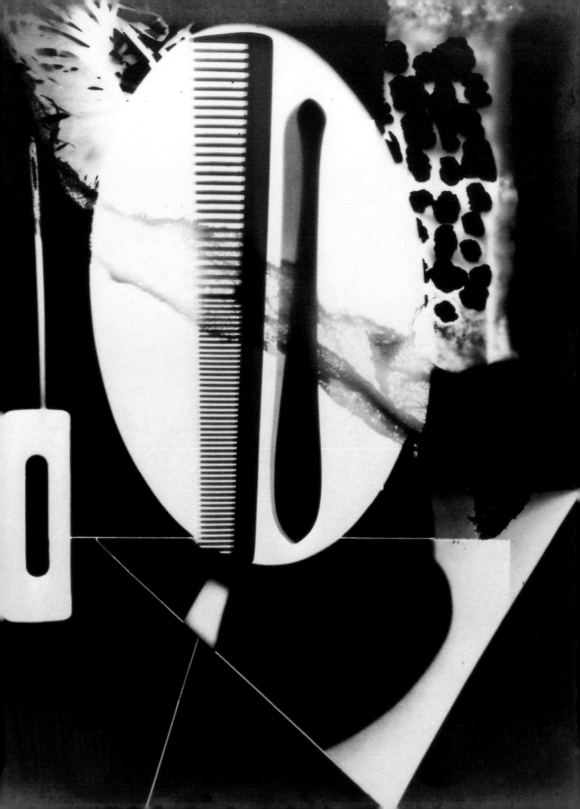

The Dada Spirit

Hugo Ball reciting a symphonic poem. poem wearing a cubist costume at the Cabaret Voltaire in Zurich (1916). © AKG Photo, Paris.
Cabaret Voltaire. Collection of artistic and literary contributions. Cover of Hugo Ball's publication (1916). © Kunsthaus, Zurich.

Tomb of the Birds and Butterflies, Jean Arp, 1916-1917. Oil painting on wood. 47 x 49 x 9 cm. © Centre Georges-Pompidou, Paris.
Rectangles arranged according to the laws of chance, Jean Arp, (1916). Collage. 40.4 x 32.2 cm. © photo Béatrice Hatala/Cnac Georges-Pompidou, Paris.

The Chocolate Grinder, Marcel Duchamp, 1913. Oil on canvas. 62 x 65 cm. © photo Béatrice Hatala/Cnac Georges-Pompidou, Paris.
Bicycle Wheel, Marcel Duchamp, 1963 (replica of the 1913 original). Private coll. © Cameraphoto/AKG Photo, Paris.

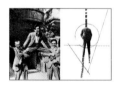

Jean Arp, Tristan Tzara and Hans Richter in front of the Elite Hotel in Zurich, 1918. © Fondation Arp, Clamart.
Dadabild, George Grosz, c. 1919. Collage. 37 x 30.C cm. © Kunsthaus, Zurich.

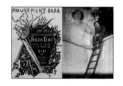

Reading by Tristan Tzara in Zurich on July 23, 1918. Poster by Marcel Janco, Dada Movement. 46.8 x 32.2 cm. Private coll. © AKG Photo, Paris.
Portrait of Tristan Tzara, Man Ray, 1921. © Centre Georges-Pompidou, Paris.

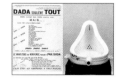

Dada Stirs it All Up, Manifesto, Paris, 1921. © Bibliothèque Nationale, Paris.
Fountain, NY, Marcel Duchamp, 1917. Porcelain (ready-made). © Mnam, Centre Georges-Pompidou, Paris.

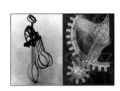

The Woman, **Man Ray.** 1920. Silver salts test. 38.8 x 29.1 cm. Musée d'Art moderne, Paris. © Mnam, Centre Georges-Pompidou, Paris
Machine, Turn Quickly, **Francis Picabia,** 1916. Tempera on paper. 49 x 32 cm. © Centre Georges-Pompidou, Paris.

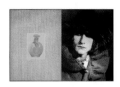

Cover of the review New York Dada. *Belle Haleine Eau de Voilette,* Marcel Duchamp, 1921. © photo Jacques Fajour/Centre Georges-Pompidou, Paris. Portrait of Duchamp as Rrose Sélavy, Man Ray, 1921. © 1921 Man Ray/Telimage 1998, Paris.

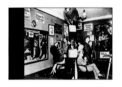

Preview of the first International Dada Fair, Burchard Gallery in Berlin, 1920. Standing: Raoul Hausmann, Otto Burchard, Baader, Wieland and Margarete Herzfelde, George Grosz and John Heartfield; sitting: Hanna Höch and Otto Schmalhausen. © AKG Photo, Paris.

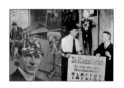

Tatlin at home, **Raoul Hausmann,** 1920. Collage, watercolors, feather. 41 x 28 cm. © Centre Georges-Pompidou, Paris.
"Art is dead...," **Grosz and Heartfield** at the Dada fair in Berlin, 1920. © Centre Georges-Pompidou, Paris.

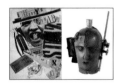

ABCD, **Raoul Hausmann,** 1923-1924. Indian ink, collage of photos and printed pages on paper. 40.4 x 28.2 cm. Musée national d'Art moderne, Paris. © Mnam, Centre Georges-Pompidou, Paris.
The Spirit of Our Time, **Raoul Hausmann,** 1919. Assembly, (wooden hairdresser's head and miscellaneous objects attached) 32.5 x 21 x 20 cm. Musée national d'Art moderne, Paris. © Mnam, Centre Georges-Pompidou, Paris.

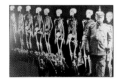

Ten Years Later: Fathers and Sons, **Jean Heartfield,** 1924. Photomontage. © Centre Georges-Pompidou, Paris.

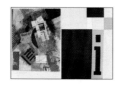

Merz 94 Grünfleck, Kurt Schwitters, 1920. Collage 26.5 x 25 cm. © Centre Georges-Pompidou, Paris.
i Bild [untitled], Jean Arp, c. 1920. Various papers, stenciled "i". 20.6 x 16.6 cm. © photo Daniel Pype/Centre Georges-Pompidou, Paris.

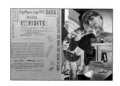

Dada excursions and visits, 1921. Poster by Tristan Tzara, 28 x 22 cm. © AKG Photo, Paris.
Da-Dandy, **Hanna Höch**, 1919. Collage. 30 x 23 cm. © Centre Georges-Pompidou, Paris.

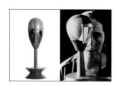

Fatagaga (Switzerland, birthplace of Dada), Max Ernst and Jean Arp, 1920. Collage on paper. 11.2 x 10 cm. © Centre Georges-Pompidou, Paris.
La Santé par le sport [Health through sports], Max Ernst, c. 1920. Photograph: blowup of an earlier montage of photographic illustrations, enhanced with Indian Ink. © Centre Georges-Pompidou, Paris.

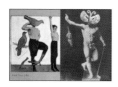

Dada head (portrait of Jean Arp), Sophie Taeuber, 1918. Turned and painted wood. H. x D: 24 x 8.7 cm. © photo Daniel Pype/Centre Georges-Pompidou, Paris.
Sophie Taeuber with *Dada head*, 1920. © Centre Georges-Pompidou, Paris.

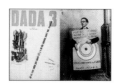

Dada n° 3, cover of the review with engraved wood by Marcel Janco, 1918. © Editions Skira, Geneva.
André Breton, targeted at the Dada Festival at the Œuvre Theater, 1920. © Centre Georges-Pompidou, Paris.

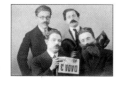

Festival Dada 3: André Breton, René Hilsum, Louis Aragon and Paul Eluard. Private coll. © Archives Marc Dachy, Paris/All rights reserved.

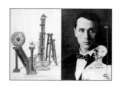

The Great Orthochromatic Wheel which Makes Love to Measure, Max Ernst, 1920. Pencil, Indian ink and watercolor on papier bis glued to cardboard. 40.8 x 27.4 cm. Musée national d'Art moderne, Paris. © Mnam, Centre Georges-Pompidou, Paris. *The Punching Ball or the Immortality of Buonarotti*, Max Ernst, 1920. Collage, photograph and poster paint on paper, 17.6 x 11.5 cm. © photo J. Faujour/Centre Georges-Pompidou, Paris.

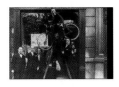

Preview at the *Au Sans Pareil* Gallery, exhibit by Max Ernst, May 1921. René Hilsum, Benjamin Péret, Serge Charchoune, Philippe Soupault, Jacques Rigaut and André Breton. © Centre Georges-Pompidou, Paris.

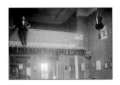

Dada exhibit in Paris, Montaigne Gallery, 1921. © Branger-Viollet, Paris.

L'Œil cacodylate, Francis Picabia, 1921. Oil on canvas and collage of photos, postcards, paper cut-outs. 148.6 x 117.4 cm. Musée national d'Art moderne, Paris. © Mnam Centre Georges-Pompidou, Paris.
Portrait of an Imbecile, Philippe Soupault, 1921. © Roger-Viollet, Paris.

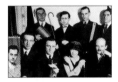

The Dada Group, Man Ray, 1921. From left to right, first row: Man Ray, Paul Eluard, Jacques Rigaut, Mick Soupault and Georges Ribemont-Dessaignes; second row: Paul Chadourne, Tristan Tzara, Philippe Soupault and Serge Charchoune. © photo Philippe Migeat/Mnam, Centre Georges-Pompidou, Paris.

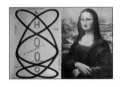

L.H.O.O.Q., Francis Picabia, 1919. Ripolin and oil on canvas. 130 x 86 cm. © Centre Georges-Pompidou, Paris.
L.H.O.O.Q., Marcel Duchamp, 1919. Pencil on a reproduction (rectified ready-made). 19.7 x 12.4 cm. © Centre Georges-Pompidou, Paris.

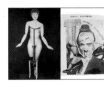

Coat Stand (Dadaphoto), Man Ray, 1920. 18 x 29.5 cm. © photo Béatrice Hatala/Centre Georges-Pompidou, Paris.
Rastadada picture, Francis Picabia, 1920. Collage on paper, 19 x 17 cm. © photo Béatrice Hatala/Centre Georges-Pompidou, Paris.

Bibliography

DACHY, Marc, *Journal du mouvement dada* 1915-1923. Geneva, Skira, 1989.

DADA, Manifestes, poèmes nouvelles, articles, projets, théâtre, cinéma, chroniques. New Edition by Jean-Pierre Bacot. Paris, Ivrée, 1994.

DADA, Zurich-Paris, 1916-1922. Paris, Jean-Michel Place, 1981.

DUCHAMP, Marcel, *Duchamp du signe. Ecrits.* Edition by Michel Sanouillet and Elmer Peterson. Paris, Flammarion, 1976.

GIBSON, Michael, *Duchamp Dada.* Paris, NEF Casterman, 1991.

HUELSENBECK, Richard, *En avant Dada. Histoire du dadaïsme.* 1920. New Edition. Paris, Allia, 1985.

HUGNET, Georges, *L'aventure dada* (1916-1923). Paris, Galerie de l'Institut, 1957.

HUGNET, Georges, *Dictionnaire du dadaïsme* (1916-1922). Paris, Jean-Claude Simoën, 1976.

LEMOINE, Serge, *Dada* (1916-1923). Paris, Hazan, 1986.

NAUMANN, Francis and VENN, Beth, *Making Mischief, Dada Invades New York.* New York, Exhibit Catalogue of Whitney Museum of American Art, 1996.

POUPARD-LIEUSSOV, Y. and SANOUILLET, M., *Documents dada.* Geneva, Weber, 1974.

RICHTER, Hans, *Dada, Art and Anti-Art.* London, Thames & Hudson, 1965, 1978.

RUBIN, Williams S., *Dada and Surrealist Art.* New York, Abrams, 1968.

SANOUILLET, Michel, *Dada à Paris.* New, Enlarged Edition. Paris, Flammarion, 1993.

SCHWITTERS, Kurt. *Merz.* Edition by Marc Dachy. Paris, Champ Libre-Ivrea, 1990.

TZARA, Tristan, *Sept manifestes dada. Lampisteries.* Paris, Budry, 1924.

The publishers wish to express their thanks to those who have provided their support for the publication of this work: Cécile Brunner (Kunsthaus, Zurich), Pierre-Yves Budzbach (Telimage, Paris), Nicole Chamson (Adagp, Paris), Micheline Charton, Carole Hubert and Christine Sorin (Centre Georges-Pompidou, Paris), Marc Dachy, Delphine Desveaux (Roger-Viollet, Paris), Corina S. Flanagan (The Beinecke Rare Book and Manuscript Library, New Haven), Bernard Garrett and Hervé Mouriacoux (AKG Photo, Paris), Madame Lovey (Skira, Geneva) and Greta Stroeh (Fondation Arp, Clamart).